These two pages are for you to fill out. Don't think too long about the answers or worry about appearing cool. If you want to write Justin Bieber just do it! No-one will judge you... OK, Maybe they will. But you know what I mean. Writing the first thing that comes into your head is usually pretty close to the truth. These answers will help you later. I've done it too, and my answers are on the next two pages.

GW00507380

A PICTURE OF ME

THINGS I LIKE 👍

THINGS I DISLIKE 👎

10 OF MY FAVOURITE FILMS

FEAR & LOATHING IN LAS VEGAS

AMELIE

FERRIS BUELLER'S DAY OFF

THE DARK KNIGHT

GOONIES

DUMB N DUMBER

INTO THE WILD

GHOSTBUSTERS

WALK THE LINE

ME AND YOU AND EVERYONE WE KNOW

10 OF MY FAVOURITE MUSIC ARTISTS

DAN LE SAC & SCROOBIUS PIP

OTIS REDDING

THE NATIONAL

ARCADE FIRE

~~JUSTIN B~~ JOHNNY CASH

BONNIE "PRINCE" BILLY

BLACK KEYS

GIL SCOTT HERON

THE ROOTS

THE VELVET UNDERGROUND

THIS BOOK WAS ~~WRITTEN~~ BY LEE CRUTCHLEY

^
DRAWN

Lee Crutchley is someone who has always hated writing text in the third person. Especially when it is text about himself. If you read the lists on these two pages you'll get a fairly good idea of the things that interest and inspire him.

Work wise he is a Graphic Designer and Illustrator, as well as the guy behind the Quoteskine project. Find out more about Quoteskine in a few pages time...

A PICTURE OF ME

THINGS I LIKE 👍

TEA

THE OCEAN

80s CARTOONS

BILL MURRAY

TRAVELLING

DRAWING

MILA KUNIS

LOTS OF ART

CHEESE BURGERS

TV COMEDY SHOWS

THINGS I DISLIKE 👎

OLIVES

MONEY

WHISTLING

INTERNET COMMENTS

GOING TO BED

ROLLERCOASTERS

IMPRESSIONISTS

LOTS OF ART

FOOD WITH A HEAD

FOOT CRAMP

"I QUOTE OTHERS
ONLY TO BETTER
EXPRESS MYSELF."

MICHEL DE MONTAIGNE

QUOTESKINE
VOLUME 1

CARPETBOMBINGCULTURE

I HAVE SOME PENS AND PENCILS
A SKETCHBOOK
AND A HEAD FULL OF QUOTES, LYRICS, AND THE LIKE

A CATALOGUE RECORD FOR THIS BOOK IS AVAILABLE FROM
THE BRITISH LIBRARY.

FIRST PUBLISHED IN GREAT BRITAIN IN 2011 BY
CARPET BOMBING CULTURE. CAMERON HOUSE, 42 SWINBURNE ROAD,
DARLINGTON, CO DURHAM. DL3 7TD
WWW.CARPETBOMBINGCULTURE.CO.UK
EMAIL: BOOKS@CARPETBOMBINGCULTURE.CO.UK

©CARPETBOMBING CULTURE

LEE CRUTCHLEY 2011
WWW.LEECRUTCHLEY.COM

For Mrs Brown, who predicted I'd get an (F) in art class
and for the kids who also hate drawing bowls of fruit

Oh, and for my family and friends

"Nothing of me is original. I am the combined effort of everybody I've ever known."
Chuck Palahniuk, Invisible Monsters

I got a Ⓑ by the way

PREFACE

If you ask most adults what their dream house would be like they'll generally tell you about the features they want. This many bedrooms, a big garden, room for 2 cars, storage space is also very important. They may even tell you about it's location, out in the country, or by the sea, anywhere but the city.

If you ask that same question to most children, you'll get a very different answer. They'd like it to be made of chocolate, with Dr Pepper flowing from the taps and a slide instead of a staircase. Children are creative by default. They haven't engaged fully with reality yet. The world is still a wonderful and exciting place to them. They have no bills to pay, no responsibilities and no "real life" pressures weighing on their mind.

Kids also draw, every single one of them. When you're a kid drawing isn't about being good, it's just about drawing and enjoying it. As we grow up most of us stop drawing, there's too many other things going on in our lives to have the time to draw. And generally as an adult, if you're not good at something, you don't do it. A lot of people feel like they can't draw so they simply don't.

I started Quoteskine after I'd been away travelling for a year. I'd got bored of real life, I quit my job, sold all my stuff and took off on a trip around the world. When I came back to England the recession had kicked in and finding a job wasn't easy. I knew there was a chance I'd be out of work for a while and I wanted to keep the creative side of my brain active while I was looking for a job.

P.T.O

Inspired by my trip I wanted to do something I loved, just for the sake of doing something I loved. I have always loved drawing, so that seemed a good place to start. And since I was about 14 I've written down quotes or lyrics that I like, in fact I have shoe boxes full of scraps of paper with them on. So combining those two things seemed like the perfect project. I set out to draw a quote every weekday in my Moleskine sketchbook.

That was it, there was no master plan and no intention to produce ultra finished illustrations. I just wanted to draw for fun, like I used to when I was a kid. I started a tumblr blog for those drawings so they existed somewhere other than my sketchbooks. Along the way that blog has picked up a few followers and been featured on a few art and design websites. At the time of writing this I've been doing Quoteskine for just over a year and a half, and I can't really believe how it's evolved.

I've had hundreds of emails from people all over the world to say they like my work, or that I've inspired them to draw again, or that I'm a wanker. It's really humbling to know that something I started because I was bored and wanted to draw has affected others and inspired them to do the same. So thanks to everyone who follows my work, for a long time I was just doing this for me, but now I'm doing it for you too.

In your hands is a kind of Greatest Hits of Quoteskine so far. I've presented the work as it is, scanned from my sketchbooks and straight into this one. I've put everything in roughly chronological order so you can kind of see how both me and Quoteskine have progressed.

If you like what you see there's plenty more at www.quoteskine.co.uk, but for now, I hope you enjoy the book.

I
DON'T
WANNA
DREAM
IF THEY
WON'T
COME
TRUE

I'M
SCARED
OF THE
MIDDLE
PLACE
BETWEEN
LIGHT
AND NO
WHERE
ANTONY AND
THE JOHNSONS

I'M JUST LIKE ANY**ONE.** I CUT AND I BLEED. AND I EMBARRASS EASILY.

MICHAEL JACKSON

IF THE GRASS LOOKS GREENER IT'S PROBABLY ASTROTURF

Absence makes the heart grow ~~fonder~~

THE FUCK UP!

GOD NEVER SAYS ANYTHING.

YOU THINK YOU'RE THE ONLY ONE HE NEVER ANSWERS?

MY ♥

IS SO

TIRED

in that
moment
i swear
we were
infinite

IF YOU LIVE TO BE 100, I HOPE TO BE 100 MINUS 1 DAY, SO I NEVER HAVE TO LIVE WITHOUT YOU

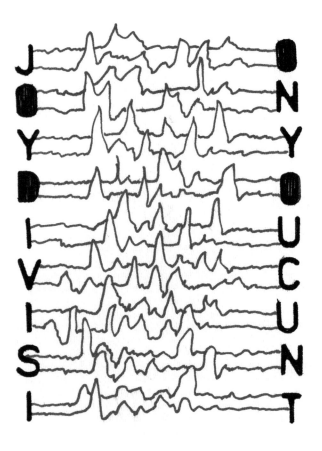

DON'T
LISTEN
TO
YOUR
HEART
IT'S
A BAD
JUDGE
OF
CHARACTER

WHEN I
WAS A KID
I WAS
HAPPY...

BUT I'M NOT A KID ANYMORE

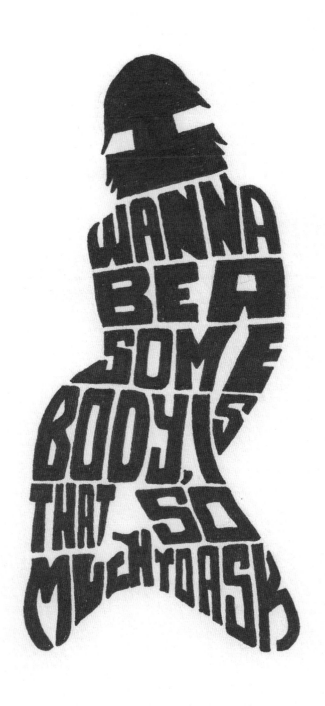

I HAVE MADE THE BIG DECISION,
I'M GONNA TRY TO NULLIFY MY
IFE. CAUSE WHEN THE BLOOD

BEGINS TO FLOW
UP THE DROP-
I'M CLOSING
NO YOU CAN'T
UYS. AND ALL
ITH ALL YOUR
OU CAN ALL GO
AND I GUESS
ON'T KNOW.
JUST DON'T
HAT I WAS
EARS AGO.
AIL THE O
N A GREAT
HIP, GOING
ERE TO THAT. IN

WHEN IT SHOOTS
PERS NECK, WHEN
IN ON DEATH.
HELP ME, NOT YOU
YOU SWEET GIRLS
SWEET SILLY TALK,
TAKE A WALK.
THAT I JUST
AND I GUESS THAT
KNOW. I WISH
BORN A THOUSAND
I WISH THAT I'D
ARKENED SEAS.
BIG CLIPPER
FROM THIS LAND
A SAILOR'S SUIT AND

AP. AWAY FROM THE BIG CITY. WHERE A
AN CAN NOT BE FREE. OF ALL THE
VILS OF THIS TOWN. AND OF
IMSELF AND THOSE AROUND. OH AND
GUESS THAT I J UST DON'T KNOW.
HAND I GUESS THAT I JUST DON'T
NOW. HEROIN, BE THE DEATH OF ME
EROIN, IT'S MY WIFE AND IT'S MY LIFE

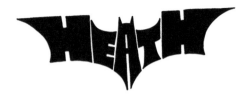

THIS WAS THE FIRST OF MY QUOTESKINE DRAWINGS
TO REALLY GET NOTICED BY ANYONE OTHER THAN ME.
IT WAS POSTED ON A FEW BLOGS AND WEBSITES.
IN THE NEXT FEW WEEKS I GAINED MY FIRST BIG
NEW WAVE OF FOLLOWERS.

BATMAN HAS ALWAYS BEEN MY FAVOURITE SUPER HERO,
AND I LOVED CHRISTOPHER NOLAN'S BATMAN FILMS.
HEATH LEDGER WAS AMAZING AS THE JOKER, THIS
WAS MY TRIBUTE TO BOTH HIS PERFORMANCE AND
HIS UNTIMELY DEATH.

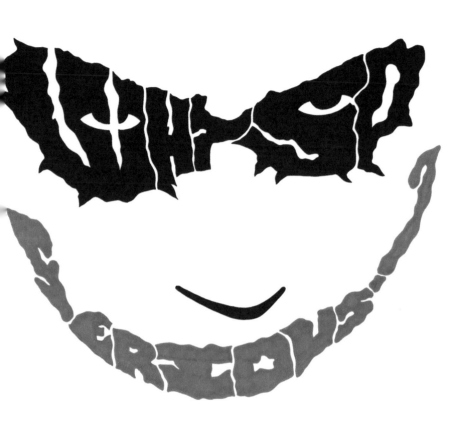

TO DO:

1) DRINK MORE WATER.

2) EAT LESS BREAD.

3) GET RICH!

S O U M X P L C N V I L O A D
F A L A H W M K Y Z O W D H X
R C K H F Z D A C F H B U Y Q
E A P O Q U Z N L S R D I V G
S V B A L I F E R A V N T O P
N E Y W K E D Y C Z J D U R S
V O E M Q H F B N O R Q H N E
R F O K A P J O W R U Y J A L
L A C Z I Y M X A Y D W A B R
O B R K N E L G E G U N Q S Q
M P G Y T N Z P H V B A P C J
Y O B C Y R I E O L I X H N P
X T E Z F D G B R U E L Y H S
M N A L W V R T E S O B W J X
K C L X B I C K D V U L R G O
J P I C H E A R G N E X I M P
P O Q V O C Y D U O K A H E N
B N U Y G M J F E N O G A W Y
R S L R V O P Q P C Y B E D Q
V N O T U E D L O P K W H X R
Y A I L X Y S J I E U F Y N Z
C B U E V I L Y N C J Q M W P
K T F G Z D E F O G A X C N B
U Z E A M Y C A B M L T F H A
S P C K X B N E T K U D E G M
Z D F G T S P Z N P X P W D H

I WALKED
DOWN TO THE
OCEAN, AFTER
WAKING FROM
A NIGHTMARE
NO MOON, NO
PALE REFLECT
ION

SOMETHIN FILLED UP MY HEART WITH NOTHIN SOMEONE TOLD ME NOT TO CRY

THIS TIME BABY I'LL BE BULLET PROOF!

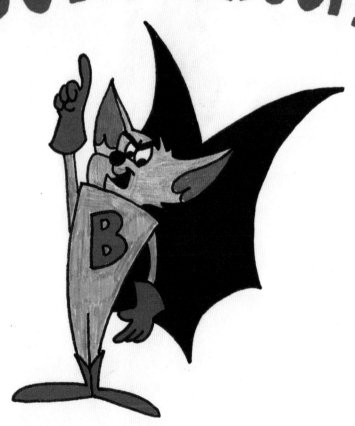

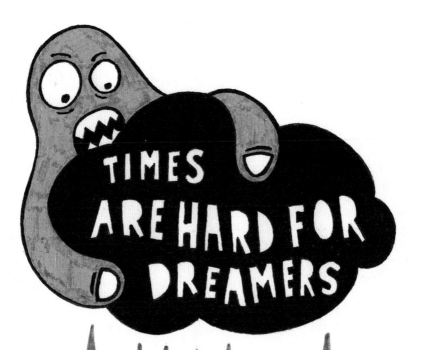

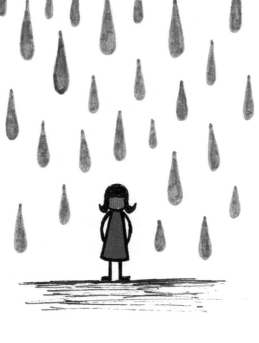

THIS IS HOW

YOU'RE YOUNG UNT

YOU LOVE UNTIL

YOU TRY UNTIL Y

YOU LAUGH UNTIL

YOU CRY UNTIL Y

AND EVERYONE MU

UNTIL THEIR DYIN

IT WORKS

L YOU'RE NOT

YOU DON'T

U CAN'T

YOU CRY

U LAUGH

ST BREATHE

BREATH

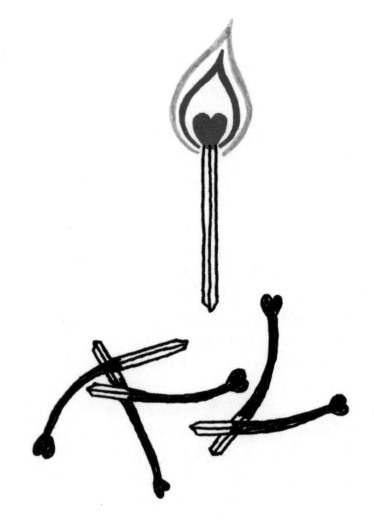

ALL SPARKS
WILL BURN
OUT IN THE END

SEX, DRUGS & ROCK N ROLL

ARE ALL VERY WELL, BUT NOTHING BEATS A NICE CUP OF TEA.

ONCE IN A WHILE, YOU GET SHOWN THE LIGHT, IN THE ST- RANGEST OF PLACES IF YOU LOOK AT IT RIGHT

KANYE VS ME VS CHRIS PIASCIK

WHEN I STARTED QUOTESKINE I KNEW I WANTED
TO START A PROJECT THAT ENCOURAGED ME TO
BE CREATIVE EVERY DAY. ONE OF MY FLICKR
CONTACTS CHRIS PIASCIK HAD A DAILY
DRAWING PROJECT THAT WAS A BIG INSPIRATION
IN ME GETTING QUOTESKINE UNDERWAY.

THE KANYE WEST MEME[1] WAS ONE OF THE FIRST
THAT I UNDERSTOOD AND THAT MADE ME LAUGH.
THERE WERE HUNDREDS OF "I'M A LET YOU
FINISH" GRAPHICS POSTED AROUND THE INTERNET.
I KNEW I WANTED TO DO A HAND DRAWN VERSION,
AND PLAYING MYSELF OFF AGAINST CHRIS SEEMED
LIKE A LOGICAL CHOICE.

[1] AN IDEA THAT IS PROPOGATED THROUGH THE WORLD
WIDE WEB. AN INTERNET MEME OFTEN EVOLVES
AND SPREADS EXTREMELY QUICKLY. MEMES SOMETIMES
REACH WORLDWIDE POPULARITY AND VANISH ALL
WITHIN A FEW DAYS.

YO! QUOTE SKINE

I'M happy FOR YOU & IMA let you FINISH BUT Chris Piascik draws SOME OF THE BEST TYPOGRAPHY OF ALL TIME!

LUST > LOVE

NOTHING IN
THE WORLD
IS MORE
COMMON
THAN
UNSUCCESSFUL
PEOPLE
WITH
TALENT

BROKEN HEARTS FIXED

FROM

£1·99

AS SEEN ON TV!

NOTHING IN
THE WORLD
IS MORE
COMMON
THAN
~~UN~~SUCCESSFUL
PEOPLE
WITHOUT
TALENT

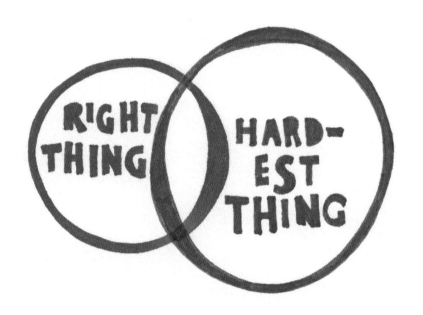

HEART FOR SALE*

*SLIGHT DAMAGE

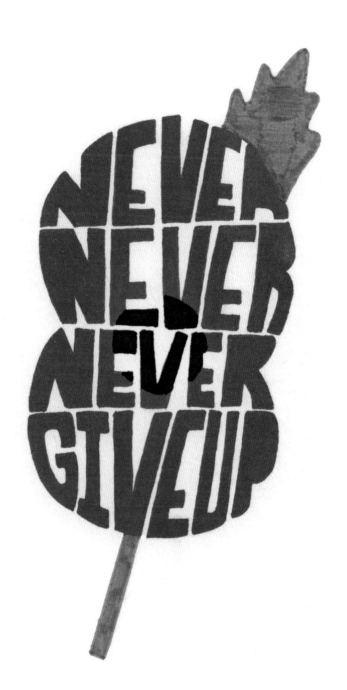

I JUST WANT BACK
IN YOUR HEAD
I JUST WANT BACK
IN YOUR HEAD
I'M NOT UNFAITHFUL
BUT I'LL
STRAY

WHY CAN
NO ONE SPELL
THESE ~~████████~~
DAYS?

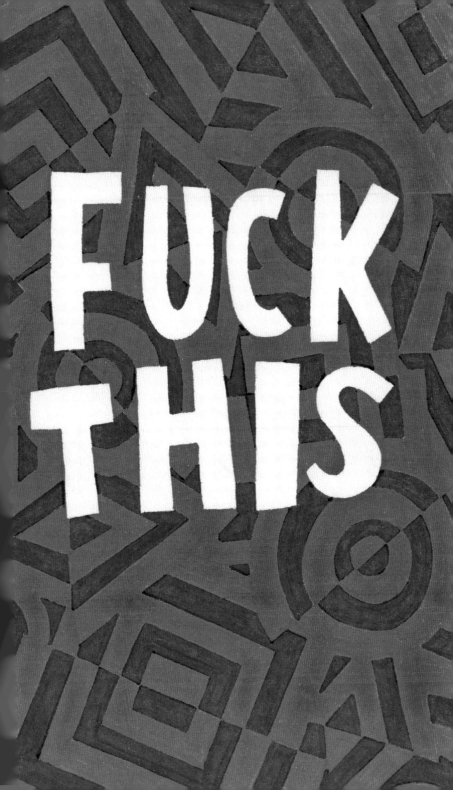

I JUST WANT SLEEP

I ❤ (DON'T KNOW) WHAT I DID BEFORE THE INTERNET

"I WOULDN'T SAY THAT I'M THE BEST MANAGER IN THE BUSINESS, BUT I AM IN THE TOP ONE"

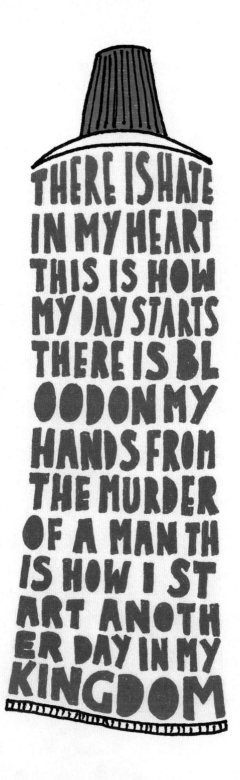

OK SO THE KUNG FU WAS COOL &SHIT BUT I'LL TAKE THE BLUE PILL

goodbye ~~cruel~~ ~~world~~ small moleskine

EUGENE F WARE

BY THIS POINT I HAD A FAIR FEW PEOPLE FOLLOWING
MY WORK. SO WHENEVER I COULD I TRIED TO FIND A
LITTLE MORE TIME TO PUSH MYSELF AND PRODUCE
BETTER DRAWINGS. UP UNTIL NOW I'D BEEN USING POCKET
SIZED SKETCHBOOKS, AND AT TIMES THEY FELT TOO
RESTRICTIVE.

SO THIS WAS MY FIRST DRAWING IN A LARGER
SKETCHBOOK. THIS QUOTE SEEMED TO FIT REALLY WELL,
WITH MOST CREATIVE PROJECTS I'VE FOUND THE BEST
THING TO DO IS JUST GET IT STARTED.

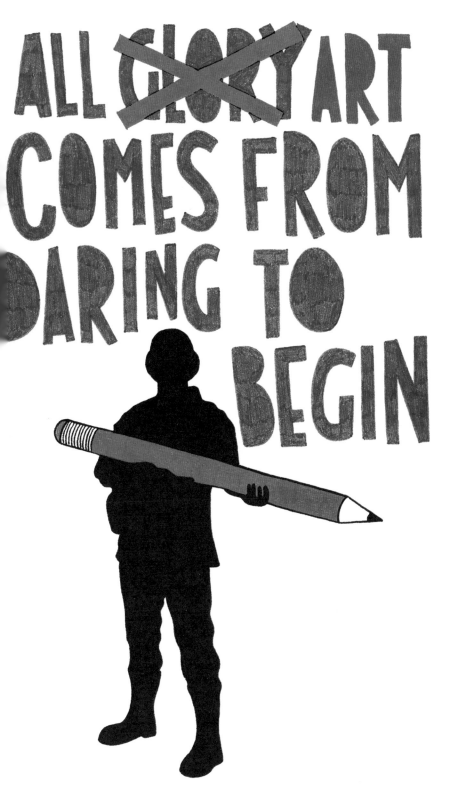

MIGHT AS WELL
FACE IT I'M
ADDICTED TO
CHUNG

I WANTED TO FUCK VAMPIRES BEFORE twilight MADE IT COOL

OH NO I SEE A DARKNES
OH NO I SEE A DARKNES
OH NO I SEE A DARKNES
OH NO I SEE A DARKNES

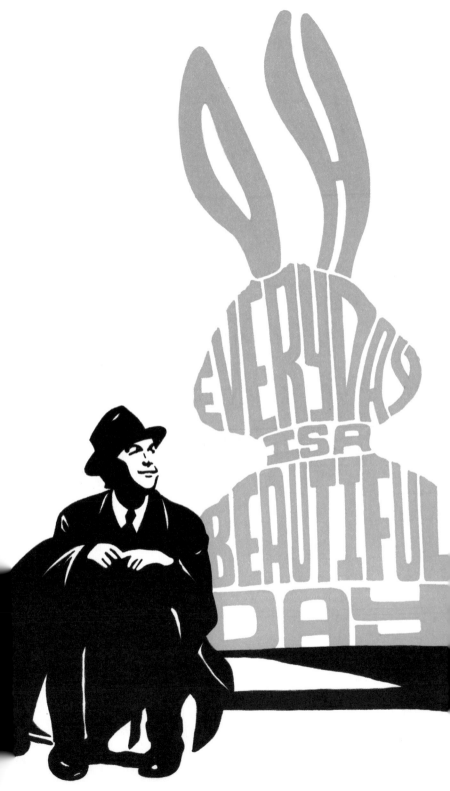

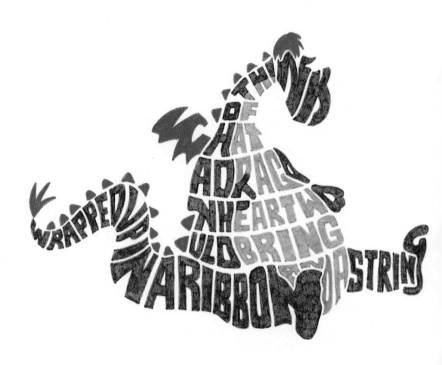

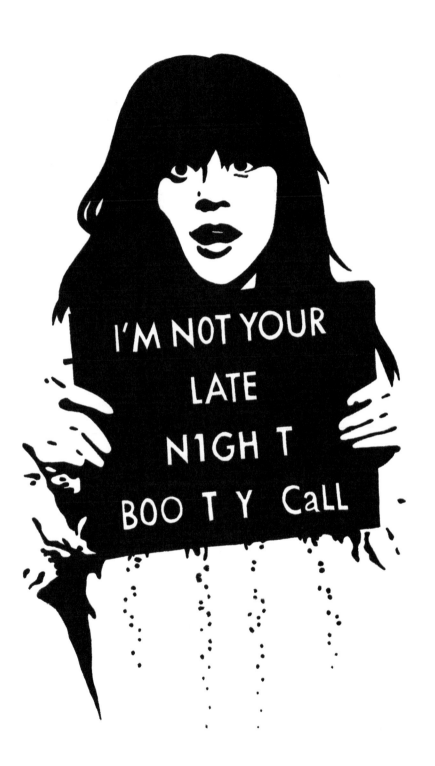

THE BEAST IN ME IS CAGED BY FRAIL AND FRAGILE BARS

CASH

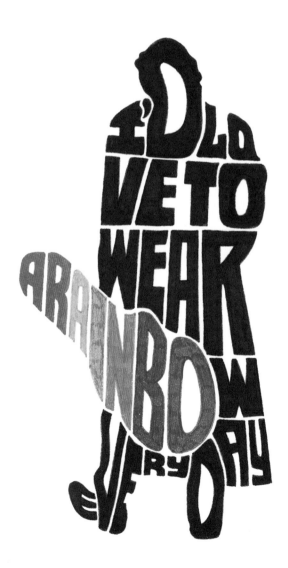

I'D LOVE TO WEAR A RAINBOW EVERY DAY

AIN'T
NOTHIN
GOIN ON
BUT THE
RENT

BEEN EATING IN THE GHETTO FROM A $100 PLATE

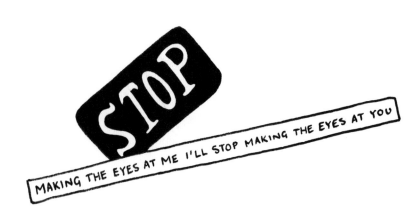

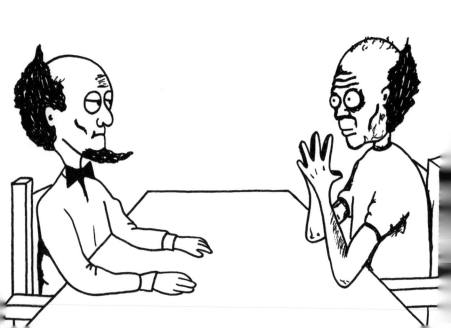

BABY TAKE OFF YOUR
COOL!

I&
LOVE&
YOU.

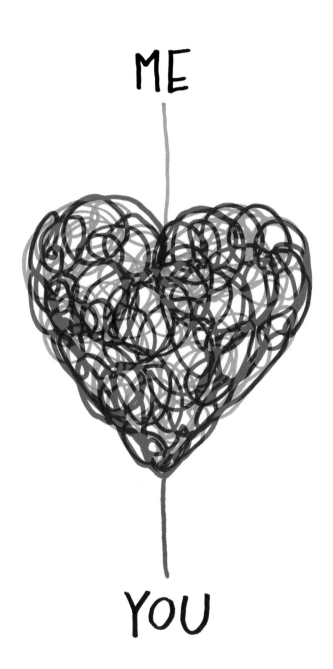

IF YOU'VE NOTHING NICE TO SAY

YOU'RE MOST PROBABLY A CUNT

Be nice to each other

Dicks

BACK TO THE FUTURE DIDN'T QUITE MAKE IT ONTO MY
"DON'T THINK TOO HARD ABOUT IT" FAVOURITE FILMS LIST,
BUT IT WAS PRETTY CLOSE! THIS WAS ANOTHER OF MY
DRAWINGS THAT MADE IT'S WAY AROUND THE INTERNET.
IT'S STILL ONE OF MY MOST POPULAR, AND MOST COPIED!

THINGS I DO WHEN WATCHING A DVD

 TURN UP THE VOLUME BECAUSE THE SPEECH IS TOO QUIET

 TURN DOWN THE VOLUME BECAUSE EVERYTHING ELSE IS TOO LOUD

 SAY "WHAT THE FUCK IS HAPPENING?"

EVERYONE THINKS THEY'RE SOMETHING SPECIAL

FUNNY, HOW FALLIN' FEELS LIKE FLYING FOR A LITTLE WHILE

FAKE

IT 'TILL YOU

MAKE

IT

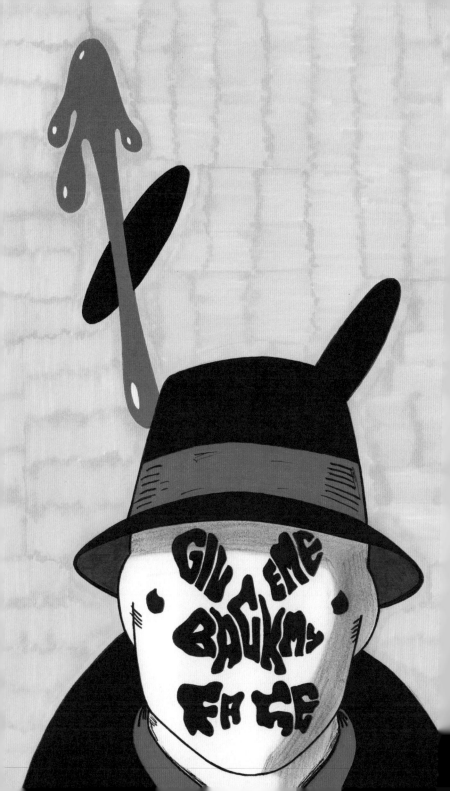

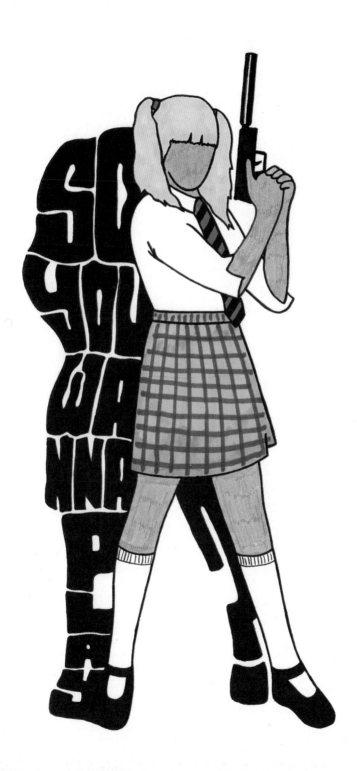

THIS WAS ONE OF THE MOST ENJOYABLE FREELANCE
PROJECTS I'VE WORKED ON. TOTAL FILM MAGAZINE
ASKED ME TO ILLUSTRATE A QUOTE BASED FEATURE
FOR THEIR WEBSITE. THEY SENT ME A LIST OF THEIR
FAVOURITE QUOTES AND BASICALLY LET ME DO
WHAT I WANTED.

THE DRAWINGS ON THE NEXT 10 PAGES ARE THE
RESULT. I ENDED UP MASHING TWO FILMS TOGETHER
ON MOST OF THE DRAWINGS. FOR NO REASON
OTHER THAN THAT'S QUITE OFTEN THE WAY MY
BRAIN WORKS.

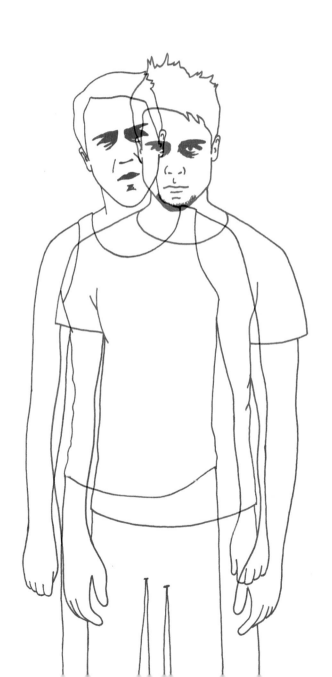

YOU MET ME AT A VERY
STRANGE TIME IN MY LIFE

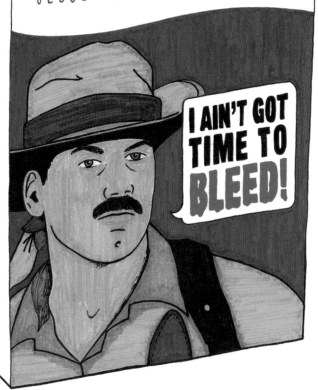

The greatest trick the Devil ever pulled
was convincing the world he didn't exist

You mustn't be afraid to dream a little bigger darling

SAY HELLO
TO MY LITTLE FRIEND

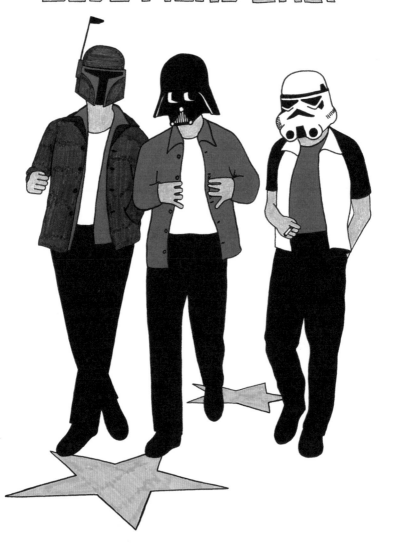

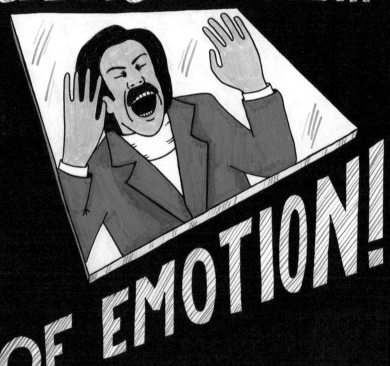

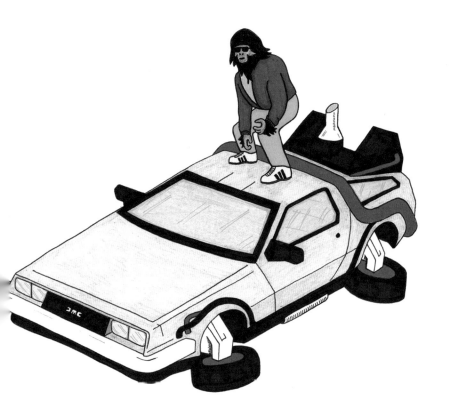

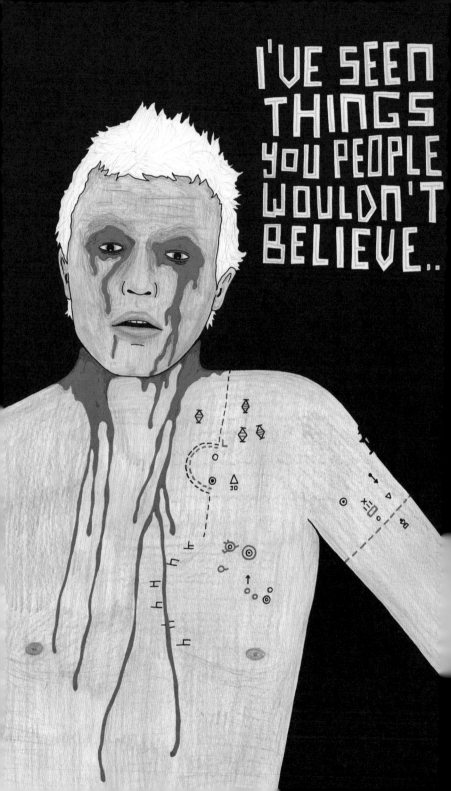

WE'VE GOT WOMEN
TALKING BACK.
WE'VE GOT PEOPLE
PLAYING STRINGED
INSTRUMENTS.
IT'S THE END OF DAYS!

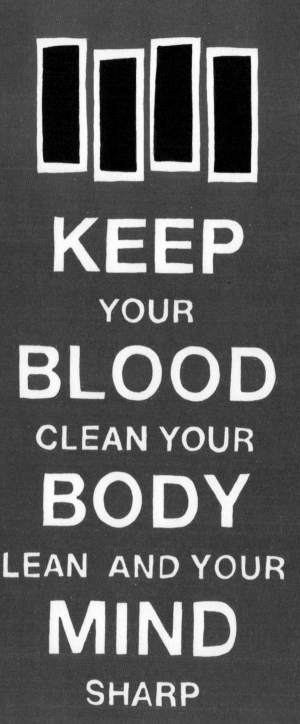

KEEP
CALM
AND
DRINK
AND
SMOKE

YOUR MOM > JESUS
LOVES YOU MORE THAN

PEOPLE WHO MAKE GENERALISATIONS ARE IDIOTS

PAGE LEFT INTENTIONALLY BLANK

One of those fucking awful black days when nothing is pleasing and everything that happens is an excuse for anger. An outlet for emotions stockpiled, an arsenal, an armour. These are the days when I hate the world, hate the rich, hate the happy, hate the complacent, the TV watchers, beer drinkers, the satisfied ones. Because I know I can be all those little hateful things and then I hate myself for realising that. There's no preventative, directive or safe approach for living. We each know our own fate. We know from our youth how to be treated, how we'll be received, how we shall end. These things don't change. You can change your clothes, change your hairstyle, your friends, cities, continents. But sooner or later your own self will always catch up. Always it waits in the wings. Ideas swirl but don't stick. They appear but then run off like rain on the windshield. One of those rainy day car rides my head imploded, the atmosphere in this car a mirror of my skull. Wet, damp, windows dripping and misted with cold. Walls of grey. Nothing good on the radio. Not a thought in my head. Lets take life and slow it down incredibly slow, frame by frame, with two minutes that take ten years to live out. Yeah, lets do that. Telephone poles like praying mantis against the sky, metal arms outstretched. So much land travelled so little sense made of it. It doesn't mean a thing all this land laying out behind us. I'd like to take off into these woods and get good and lost for a while. I'm disgusted with petty concerns; parking tickets, breakfast specials. Does someone just have to carry this weight? Abstract typography, methane covenant, linear gospel, Ashville sales lady, stocky, an emissary, torturous lice, mad Elizabeth. Chemotherapy bullshit. The light within you shines like a diamond mine, like an unarmed walrus, like a snake eating its own tail, a steam turbine, frog pond, too-full closet burst open in disarray, soap bubbles in the sun, hospital death bed, red convertible, shopping list, blowjob, death's head, devils dancing, bleached white buildings, memory, movements, the movie unreeling, unreeling, about to begin. I've seen your hallway, you're a dark hallway. I hear your stairs creak. I can fix my mind on your yes, and your no. I'll film your face today in the sparkling canals, all red, yellow, blue, green brilliance and silver Dutch reflection. Racing thoughts, racing thoughts. All too real. you're moving so fast now I can't hold your image. This image I have of your face by the window, me standing beside you arm on your shoulder. A catalogue of images, flashing glimpses then gone again. I'm tethered to this post you've sunk in me, every clear afternoon now I'll think of you up in the air, twisting your heel, your knees up around me, my face in your hair. You scream so well, your smile so loud it still rings in my ears. Inhibition. Distant, tired of longing. Clean my teeth. Stay the course. Hold the wheel. Steer on to freedom. Open all the boxes. Open all the boxes. Open all the boxes. Times Square midday; newspaper buildings, news headlines going around, you watch as they go, and hope there's some good ones. Those tree shadows in the park they're all whispering chasing leaves. Around six pm, shadows across cobblestones, girl in front of bathroom mirror she's slow and careful and paints her face green, mask like. Like Matisse. Portrait with green stripe. Long shot through apartment window, a monologue on top but no girl in shot. The light within me shines like a diamond mine, like an unarmed walrus, like a dead man face down on the highway. Like a snake eating its own tail, a steam turbine, frog pond, too-full closet burst open in disarray, soap bubbles in the sun, hospital death bed, red convertible, shopping list, blowjob, death's head, devils dancing, bleached white buildings, memory, movements. The movie unreeling, about to begin.

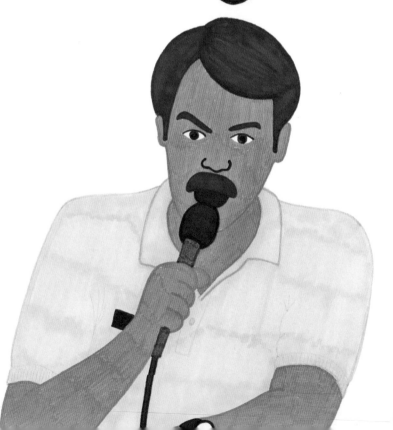

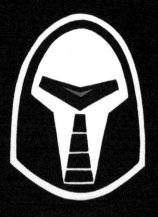

DON'T
FRAK
WITH
THE
CYLONS

IT DOES
NOT MATTER
WHAT YOU
HAVE IN
YOUR LIFE

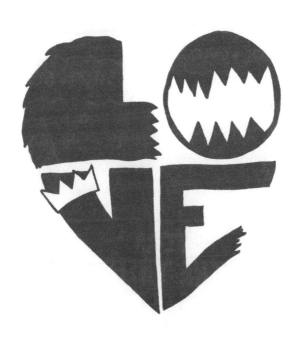

IT'S A MYSTERY

YEAH
THE TREES
THOSE USELESS TREES
THEY NEVER SAID
THAT YOU
WERE LEAVING

HO:PE

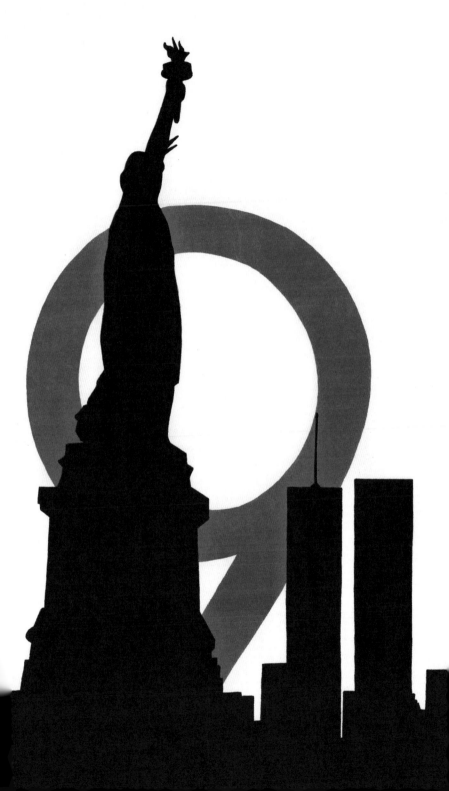

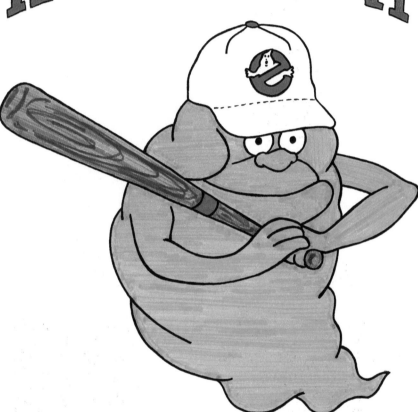

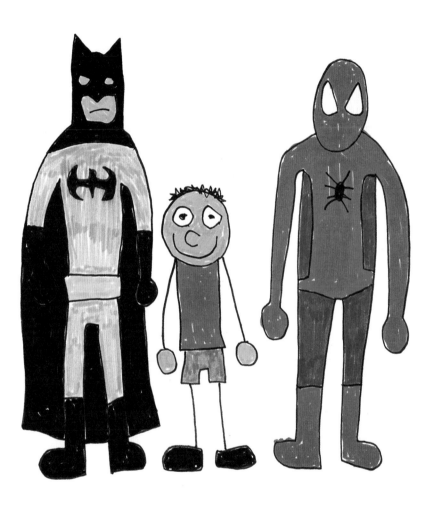

I never had any friendz later
on like the onez I had when I
waz twelve.

Jezuz!. doez anyone?

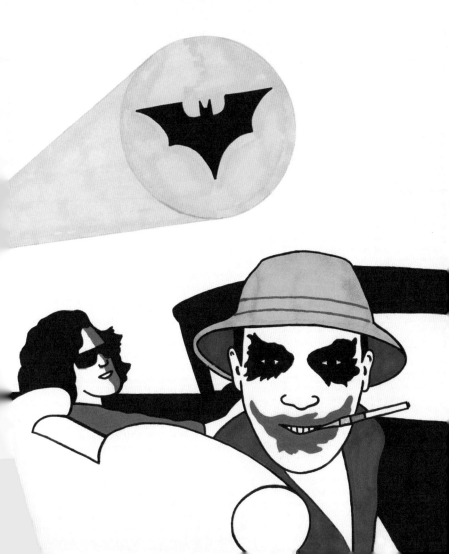

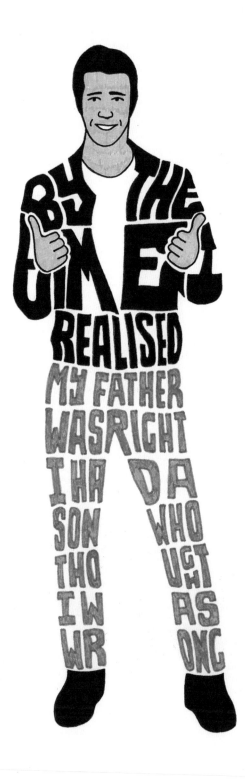

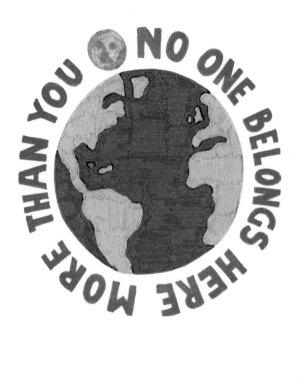

REALITY > RELIGION

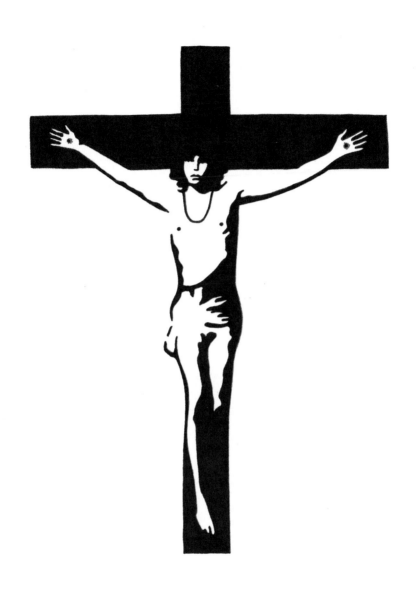

Did you have a good world when you died?
Enough to base a movie on?

What's happening?

140 characters is far too many to represent the mundane yet tweetable events that occur in my life on a minute by minute basis..... Apricots.

Latest:

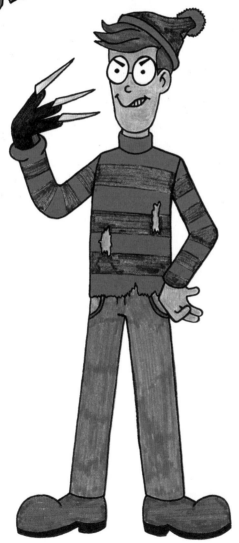

I'M SURE

EVERYTHING WILL BE "OK"

BUT I'D PREFER IT TO BE AWESOME!

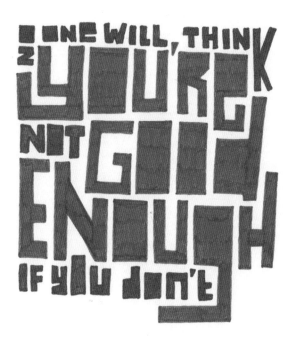

No one will, think you're not good enough if you don't

LIFE IS PERFECT

-LY ADEQUATE.

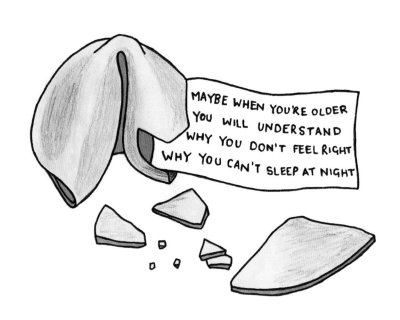

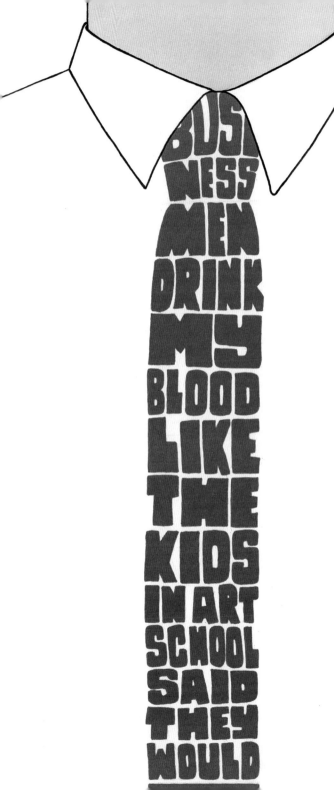

LORD OF THE PRANCE

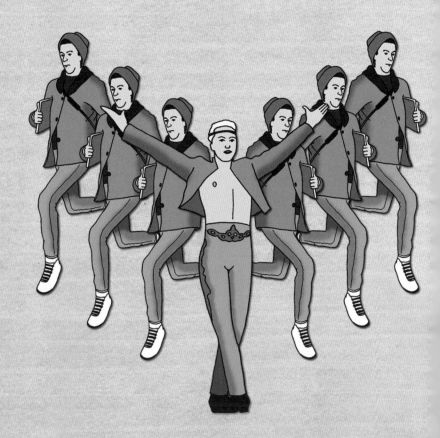

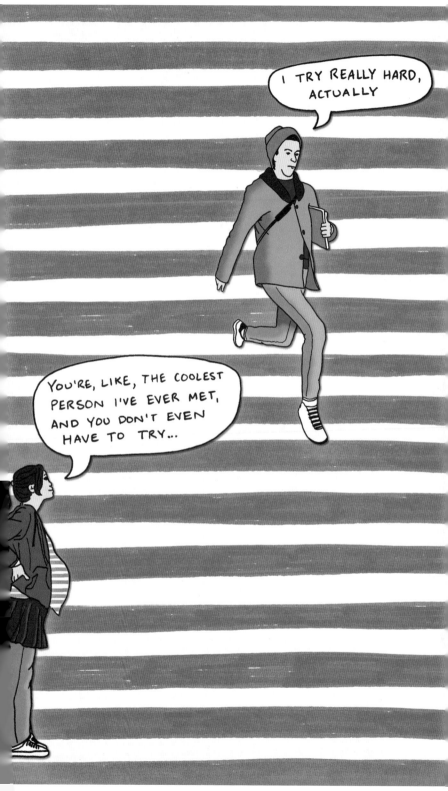

PRANCING MICHAEL

(PREVIOUS 2 PAGES)

THIS WAS ANOTHER INTERNET MEME THAT REALLY MADE ME LAUGH. IT STARTED WITH A PHOTO THAT EDGAR WRIGHT TOOK OF MICHAEL CERA JUMPING BETWEEN TWO PLATFORMS.

IT QUICKLY BECAME THE 'PRANCING MICHAEL' MEME, WITH THOUSANDS OF PRANCING VARIATIONS BEING POSTED AROUND THE INTERNET ALMOST INSTANTLY. THESE WERE MY COUPLE OF PRANCING MICHAELS. THEY WERE ALSO THE FIRST, AND SO FAR ONE OF THE ONLY TIMES I'VE USED ANY DIGITAL ILLUSTRATION FOR A QUOTESKINE.

FOR KATE

(THIS PAGE)

THIS DRAWING CAME ABOUT AFTER AN EMAIL FROM A LADY CALLED KATE. SHE WAS HAVING A ROUGH TIME AND ASKED IF I COULD DO A DRAWING TO CHEER HER UP. SHE'D JUST FOUND OUT HER HUSBAND WAS BEING POSTED ABROAD WITH THE ARMY.

KATE SAID SHE WOULD EVEN BE HAPPY WITH A DRAWING OF A STICK MAN SAYING 'NO'. BUT I WANTED TO DO HER SOMETHING A BIT MORE MEANINGFUL. PLUS I'M AWFUL AT DRAWING STICK MEN!

QUOTE VIA LOVING LONG DISTANCE

Distance means so little when
someone means so much

Me You

Us

LOVE

"THE SCARIEST THING YOU'LL SEE ALL YEAR"
★★★★★

WAITING FOR
THE BEAT
TO KICK IN

BUT IT NEVER DOES

I HATE THE WAY PEOPLE COMMENT ON THINGS,
THAT THEY DON'T UNDERSTAND.
I HATE THE WAY YOU STOP ME DOING,
ALL THE THINGS THAT I HAD PLANNED.
I HATE THE WAY YOU TELL ME THINGS,
YOU THINK I'D LIKE TO BUY.
OF COURSE I WANT TO BUY THAT SHIT,
BUT I ALSO WANT TO FLY.
I HATE THE WAY THE DEFAULT OPINION IS,
I'M RIGHT AND YOU ARE WRONG.
I HATE THE WAY IT'S A COMPETITION,
FOR FRIENDS TO GET ALONG.
I HATE THE WAY I GET TAGGED IN PICTURES,
BUT WORSE, I HATE I CARE.
I HATE THE WAY YOU SHOW ME BOOBIES,
AND THAT YOU MAKE ME STARE.
I HATE THE WAY THE FIRST THING I THINK IS,
ERM, I'LL GOOGLE IT.
BUT MOSTLY I HATE THE WAY I DON'T HATE YOU,
NOT EVEN CLOSE,
NOT EVEN A LITTLE BIT,
~~NOT EVEN AT ALL~~.
OK, MAYBE A LITTLE BIT.

I ♥ THE INTERNET

YOU'RE PUSHING THIRTY SLUGGER IT'S TIME TO THINK ABOUT GETTING SOME AMBITION

WELL I ALWAYS FIGURED I'D LIVE A LITTLE BIT LONGER WITHOUT IT

Below is an index of all the references used to create the drawings in this book. The pages that don't have a reference listed are phrases that I've come up with myself, and I'm trying to do more and more of that as time goes on. But Quoteskine definitely wouldn't be possible without all of the films, books, songs and people listed on these two pages. So I'd like to say a huge thanks to all the writers, directors, musicians and anyone else who has had a part in creating anything I've ever used, or will use in the future as inspiration for a drawing.

THANKS!

AND SORRY MOM & GRAN FOR ALL THE SWEARING

NOW IT'S YOUR TURN!

ON THIS PAGE DRAW YOUR FAVOURITE "song lyric"

ON THIS ONE DRAW A QUOTE FROM YOUR FAVOURITE **FILM**

ON THIS PAGE DRAW A QUOTE THAT
MEANS SOMETHING TO YOU